Amy,

SEE YOU ON THE TRAIL —

2003

*Black & White*

# GLACIER CLASSICS

PHOTOGRAPHY BY    **BRET BOUDA**

EDITED BY    **TOM ESCH**

A lot of people have helped me in many ways during the years I have devoted to nature photography. To all I am grateful, but I regret that space precludes naming every one of them. Some, however, MUST be named, for their friendship, interest, and encouragement have greatly contributed to bring this classic collection of recent black and white photographs of  Glacier National Park (in  celebration of the Park's first 100 years) from concept to completion. My thanks go to: Al Benavides whose friendship, financial, and moral support sent me on the way to become a full time photographer; Tom Esch who has written the text  and helped with editing the photographs captions and whose passion for the Park and nature became very instrumental in my career as a nature photographer; and, of course, my wife, Karen.

This book was made to celebrate the beauty of Glacier National Park
for nature's friends of all ages.

First Edition

A Digital Broadway LLC book

www.digitalbroadway.com

ISBN # 978-0-615-20533-5

Printed in China

As the 100th anniversary of the founding of Glacier National Park approaches, it is appropriate to reflect on the unique qualities that make this park special. Qualities that inspired the founders – Qualities that inspire the visitor today – Qualities that will endure tomorrow – Classic Qualities – Glacier Qualities!

Glacier is a feast for the senses. The feast is heard in the whispers of the wind, the cascading of water, the ricochet of a rock slide. The lingering scent of beargrass, spruce, and lichen on a sunny day fills the air. The sweet taste of huckleberries along the trail or the bitterness of the wildfire smoke challenges the taste buds. Yet the touch of cold, refreshing water on sore, tired feet from the long hike or the wet thimbleberries brushing on the legs refreshes even the weariest hikers.

Of all the senses, sight is what overwhelms the visitor initially and continues to overwhelm with each succeeding encounter. Light is reflected in the sedimentary rock formed billions of years ago as well as on the delicate glacier lily bravely emerging from the winter snow. The reflection of the sky and craggy mountains in the clear, blue lakes sparkle with light in the polished red and greens of argillite along the creek bottom. Light is the source of inspiration, wonder, and awe. Just maybe, light is the conduit for such things.

Why black and white? There is no better medium that conveys the sense of classic light than that found in landscape. The inspired visitor is certain to encounter something that is permanent, eternal, and timeless. The park aficionado eventually realizes that what appears permanent is in reality, dynamic. Forests burn and grow again, glaciers recede and rocks erode eventually all deposited into the three oceans to which it drains. These snapshots record the image of a particular space at a particular time. May they trigger a memory of a cherished day or spark a desire to explore a new trail in this classic landscape.

Glacier is vast. To say that it is over 84 million acres doesn't register with those of us who mow our lawns of a quarter acre. The vastness is compounded by the pristine condition of the Park as well as its topography. The deep canyons, primeval forests, hidden cirques and precipitous peaks create the illusion that this landscape is bigger than a calculation of the surface area. And it is.

What is the best way to experience this vastness? Many are content to stay in the wonderful lodges or campgrounds and drive over the spectacular and historic Going-to-the-Sun Road never venturing far from the amenities and imprint of human incursion onto this landscape. Others are compelled to hike the miles of trails on a mission of task completion as if the more miles of trail that is hiked the closer one becomes to the landscape.

Glacier exists during more than one season. Glacier exists more than one time of day. A full experience would include an effort to see the landscape at different times of the year. If that is not possible then consciously strive to see it at different times of the day. The "magic hour" of light takes place at sunrise and at sunset. Sometimes staying in one place and watching the landscape be changed by the light is as rewarding as driving on to the next turnout or hiking another mile of trail. The change of light can be inspiring.

Some of the best light is filtered through the lens of clouds and inclement weather. Rather than scurrying for the car or the lodge or the campground the next time the rain cloud comes put on a raincoat and watch as the mist swirls around a ridge. Notice how the waterfalls get bigger after a rain.

If it's a hot summer day take your socks off and dangle your feet in a creek. Where else can you wonder if this water is a collection of droplets from yesterday's rain or was it recently released from a glacier that had been holding it since the Pleistocene? But be careful. More people have been killed by falling in the creeks in Glacier than by being eaten by grizzly bears.

Which bring us back to the topic of the illusion of vastness. Does this place seem bigger because it is a place that we can not completely control? We're not the top of the food chain here. We can't stop an avalanche or a rock slide or a forest fire or a glacier from melting.

To some these facts when pondered are unnerving.

To others they are liberating.

To others they are both.

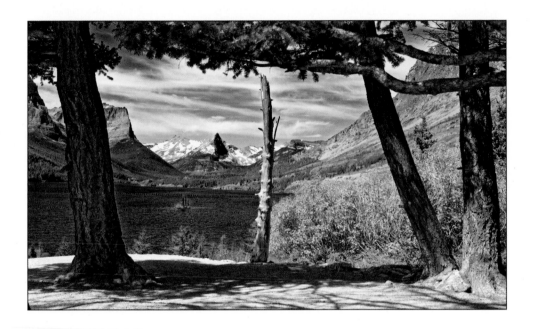

### St. Mary Lake

is located on the east side of the park. The Going-to-the-Sun Road parallels the lake along its north shore. At an altitude of 4,484 feet, St. Mary Lake's waters are colder and lie almost 1,500 feet higher than Lake McDonald, the largest lake in the park.

There is some controversy over the origin of this name as applied to St. Mary Lakes. JW Schultz states that Father Pierre DeSmet, the Belgian Missionary named the lakes, but DeSmet's papers and records do not indicate that he ever reached the lake. Other accounts state that the name was given to the St. Mary River by the International Boundary Survey party in 1870. It is more probable that the name was given by Hugh Monroe, the first European to live with the Blackfeet Indians, probably shortly after first arriving in the country in 1814.

## Going-to-the-Sun Road

Completed in 1932 it is the only road that crosses the park, going over the Continental Divide at Logan Pass. A fleet of 1930s red tour buses (known as "Jammers" for their grinding gears) offer road tours. In 2001 the busses were rebuilt to run on propane. The road, a National Historic Landmark and a Historic Civil Engineering Landmark, spans 53 miles.

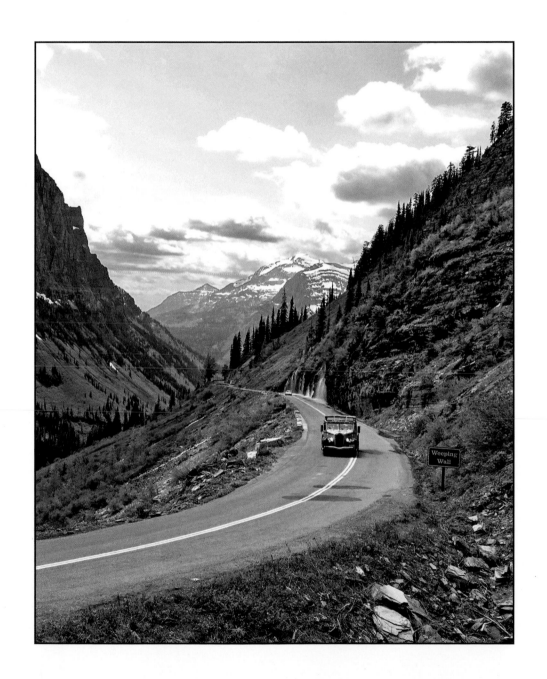

## Going-to-the-Sun Road

The road is one of the most difficult roads in North America to snowplow in the spring. Up to 80 feet of snow can lie on top of Logan Pass, and more just east of the pass where the deepest snowfield has long been referred to as Big Drift. The road takes about ten weeks to plow, even with equipment that can move 4,000 tons of snow in an hour. The snowplow crew can clear as little as 500 feet of the

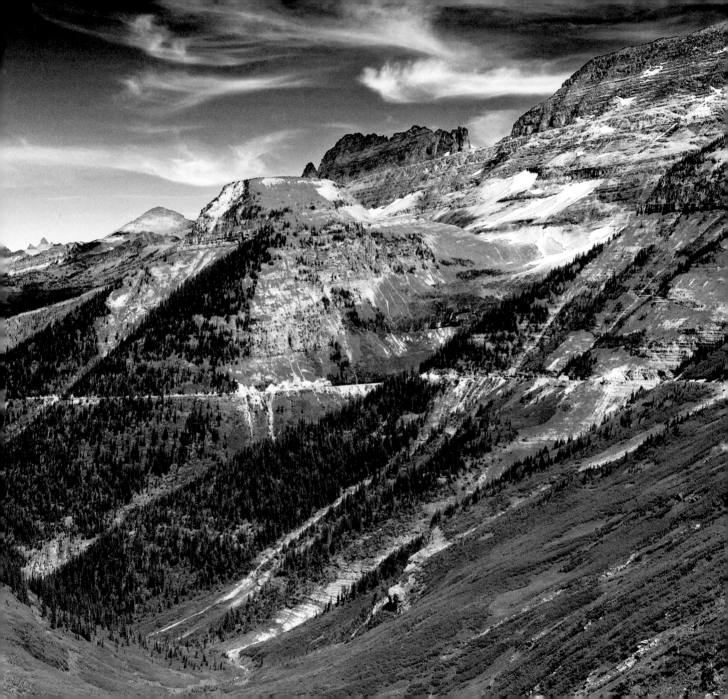

## Trail of the Cedars

A handicaped hiking trail on the west side. The path includes a raised boardwalk or is paved. It is 0.6 miles long, leads through a shaded forest of hemlock, cottonwood, fir, larch, and of course, contains many ancient red cedar trees.

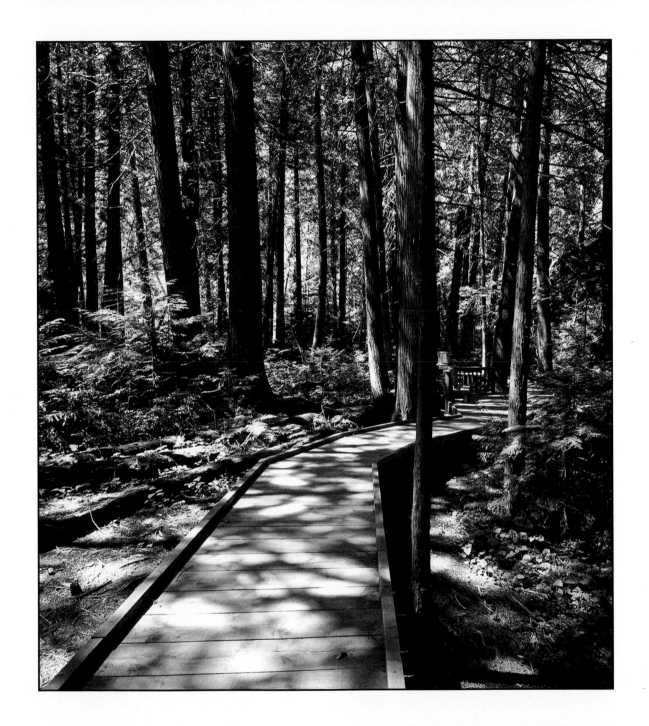

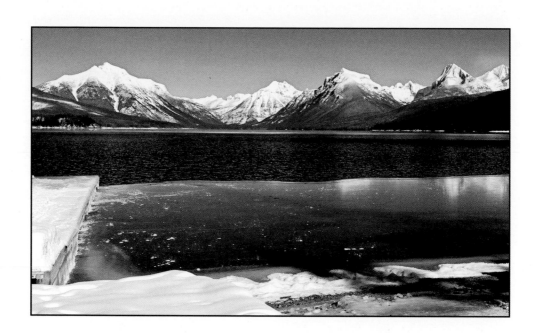

**Lake McDonald**
is the largest lake in Glacier National Park. It is approximately 10 miles long, and over a mile wide and 472 feet deep, filling a valley formed by a combination of erosion and glacial activity. Lake McDonald lies at an altitude of 3,153 feet and is on the west side of the Continental Divide.
Across lake left - right: Stanton Mtn (7,750) with Mt. Vaught (8,850) peering over its shoulder, in distance is the Garden Wall; right Mt. Cannon (8,952), Mt. Brown (8,565) and Edwards Mtn (9,072).

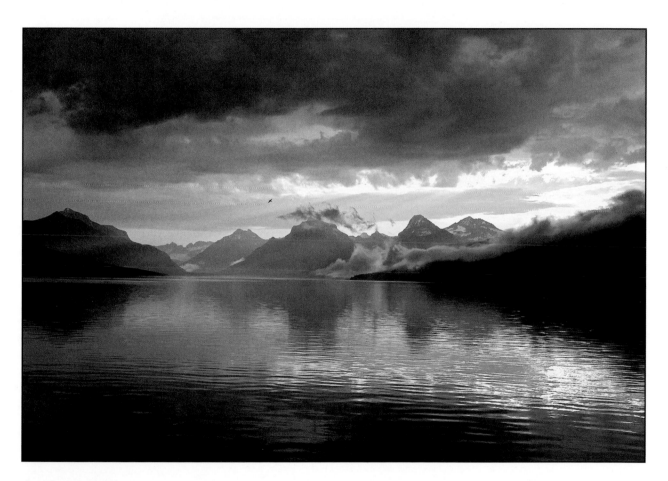

## Lake McDonald

In about the year 1878, Duncan McDonald visited this lake, which was then known as "Terry Lake", for General Terry, notoirious Indian fighter of the west. While in camp that evening McDonald carved his name upon the bark of a birch tree. The tree bearing his name remained for many years near the present village of Apgar. People who saw the name on the tree gradually began to call it McDonald's Lake.

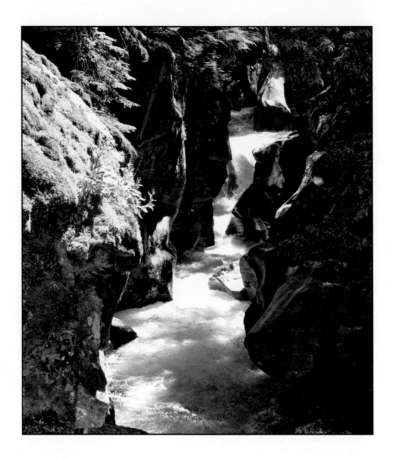

**Avalanche Gorge**
A beautiful waterfall at the upper end of the Trail of the Cedars has carved through colorful rock to make a channeled stream through the rock. An interesting contrast is provided by the shaded canyon walls and the shinning water.

Hundreds of waterfalls and creeks are scattered throughout the park; however, during dryer times of the year, many of these are reduced to a trickle.

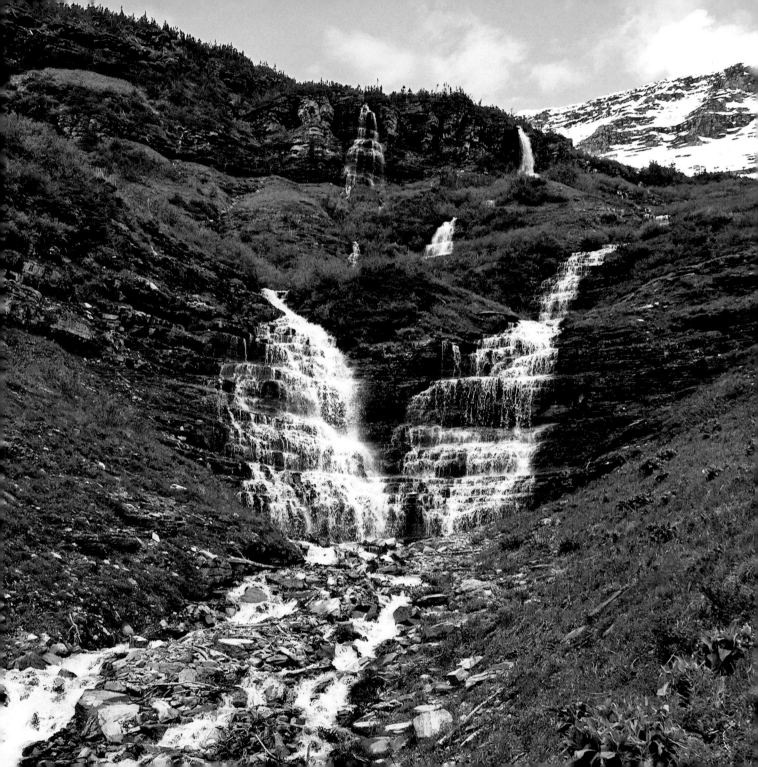

**Heaven's Peak**

A descriptive name that first appears on a map prepared in 1888-1890 by Infantry Lt. George P. Ahern.

The peak is 8,987 feet high and rises over 5,000 feet above its base. It dominates the view from much of the Going-to-the-Sun road and with its permanent snow (no longer glaciers) is quite photogenic.

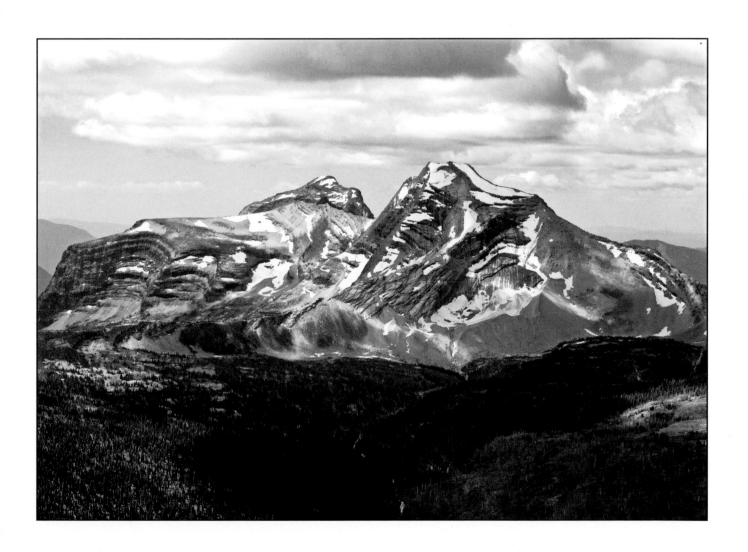

**Heaven's Peak**
Heaven's Peak is the highest of four peaks that form the
divide between Camas Creek and McDonald Creek.

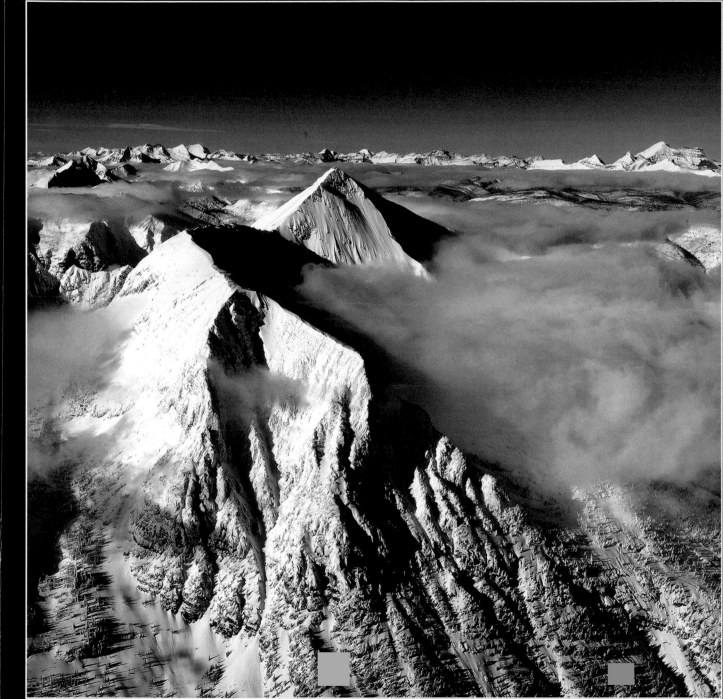

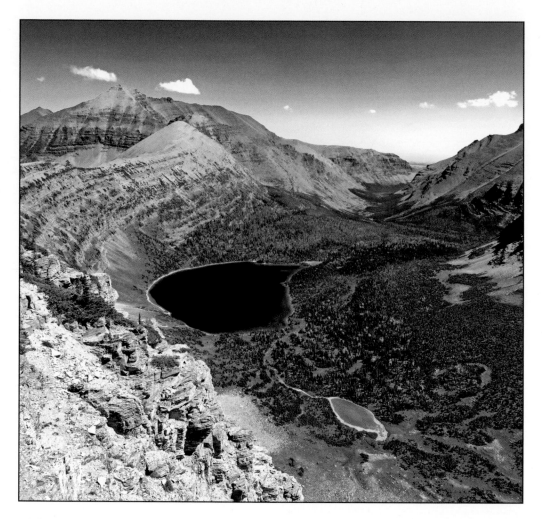

**Old Man Lake**
(a tarn) and the cirque under Pitamakan pass.

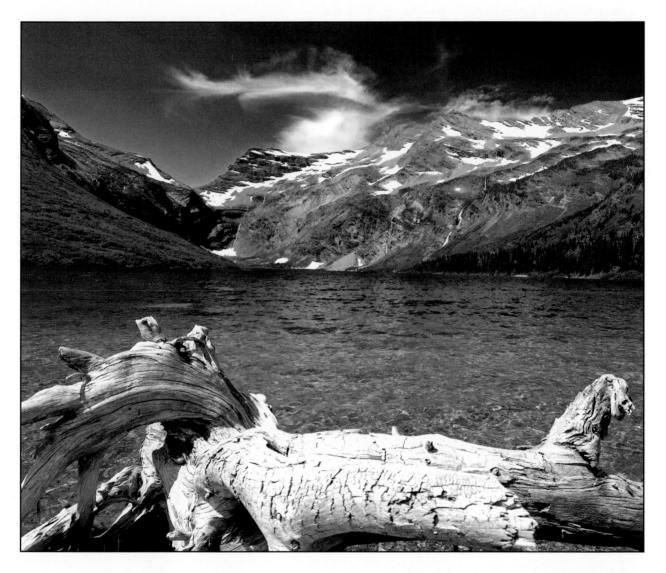

**Gunsight Lake bellow Gunsight Pass**
Was named in 1891 by G. B. Grinnell for its resemblance to the rear sight of a rifle.

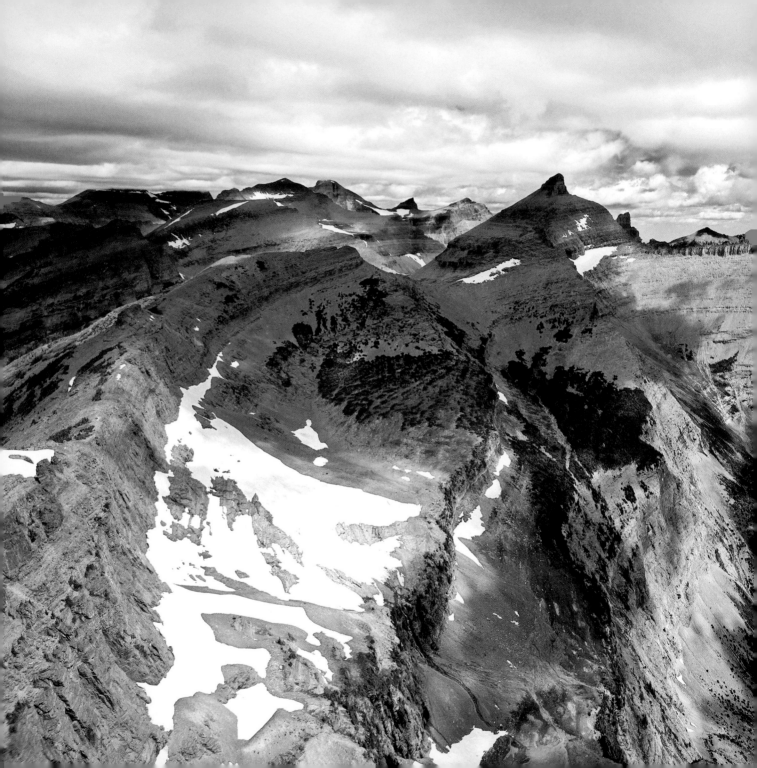

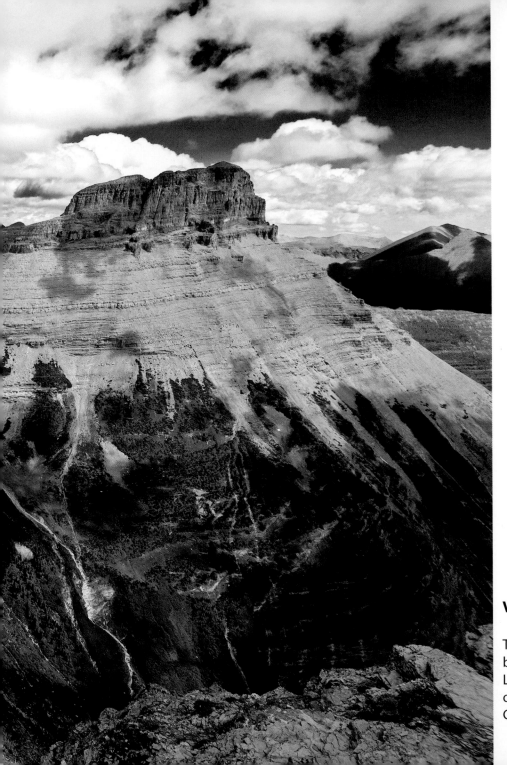

**View from Swiftcurrent Lookout**

This extensive view can be obtained by climbing the trail to Swiftcurrent LO. It sits on Swiftcurrent Mt. (8,436) on the Continental Divide between Granite Park and Many Glacier.

**Comeau Pass**
Steep and narrow staircase cuts into the stone head wall of
Comeau Pass leading to the Sperry Glacier Basin.

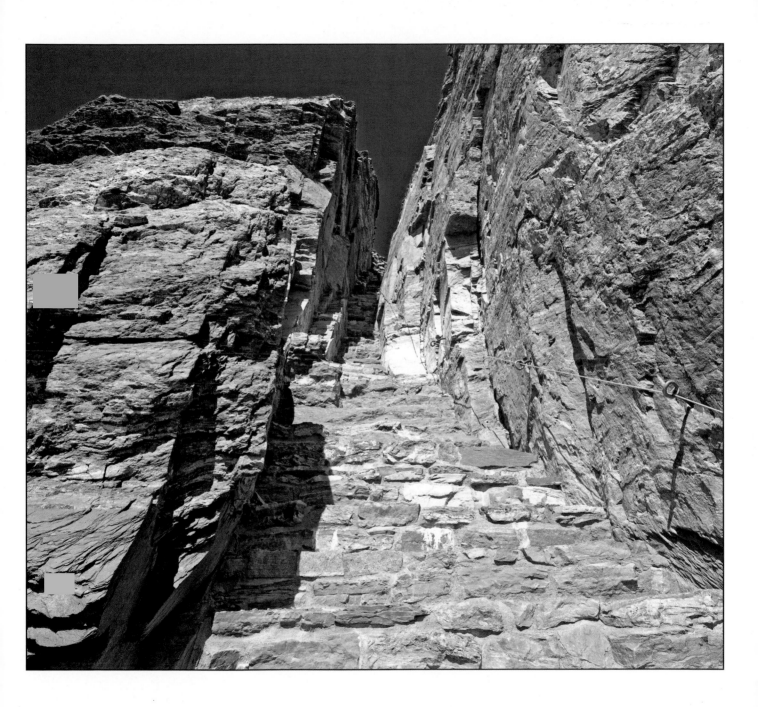

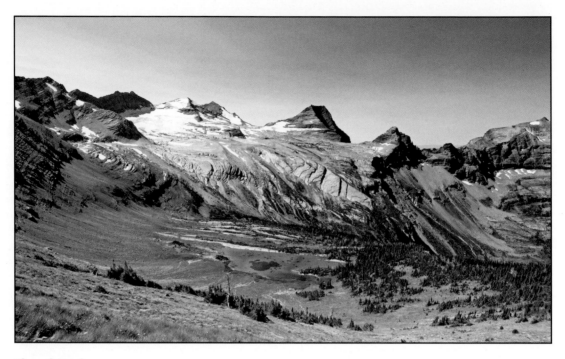

**Floral Park**
Floral Park above Avalanche Basin is characteristic of much of Glacier's subalpine zone.

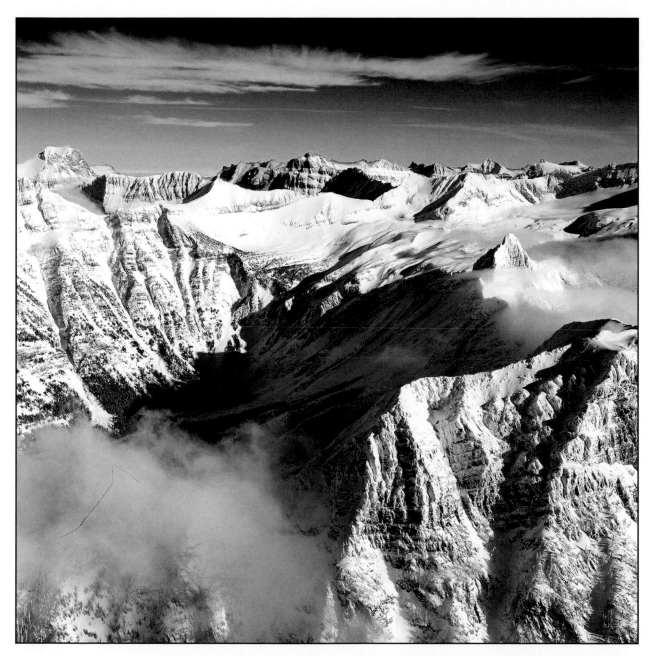

The aerial view of Floral Park with the Little Matterhorn rising through the mist.

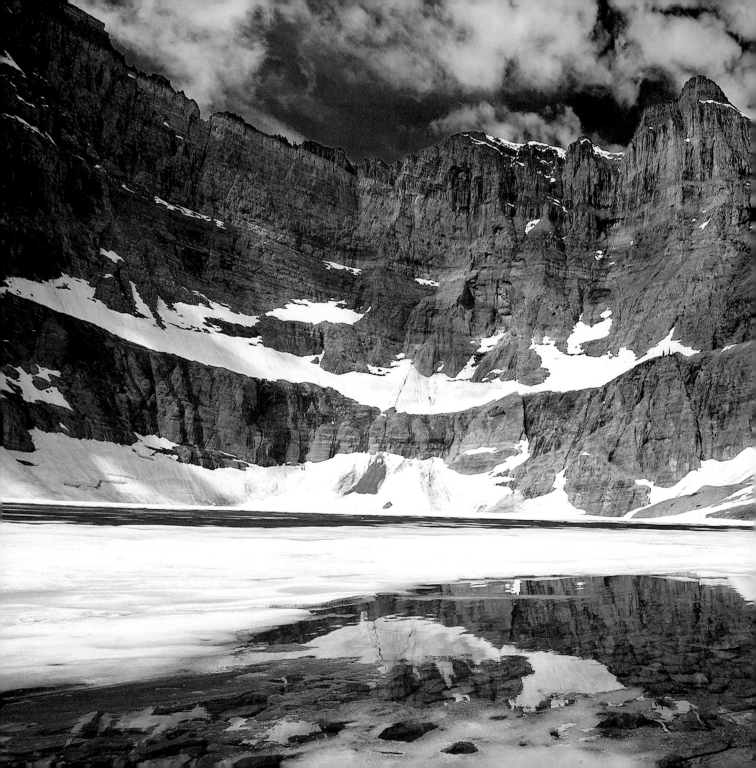

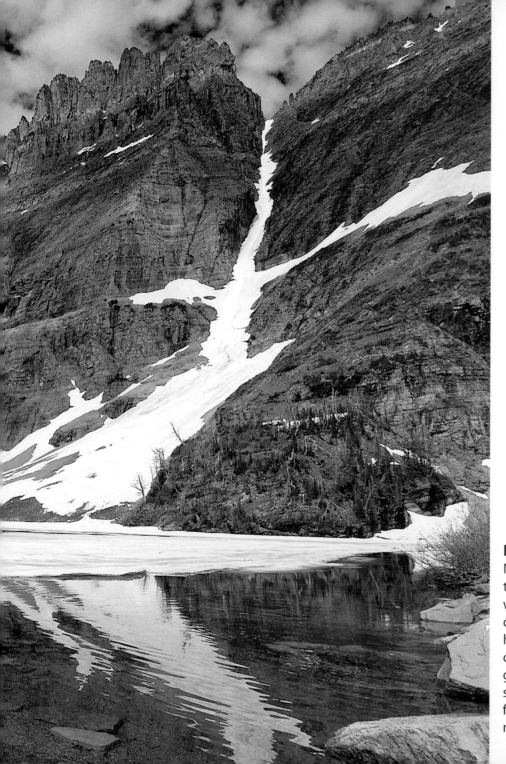

## Iceberg Lake

Named after the many icebergs that are found floating in its waters, Iceberg Lake sits high in a cirque, a steep wall found at the head of a glacial valley. Technically, Iceberg Lake is a tarn, or glacially carved lake that was sculpted long ago. The glacier that formed the lake no longer (for now?) exists.

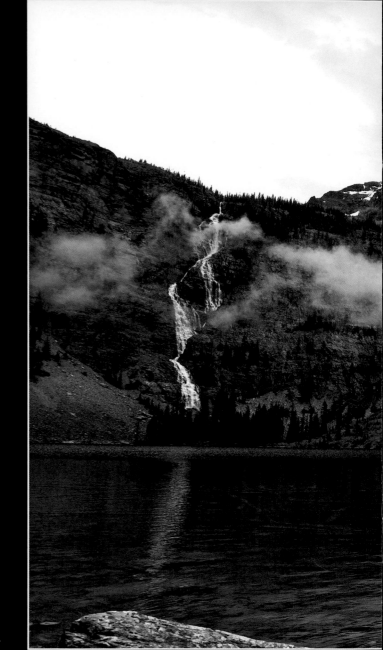

## Beaver Chief Falls

Beaver Chief Falls cascades from Lake Ellen Wilson to Lincoln Lake. From a photographer's eye, the lighting of Beaver Chief Falls is a dream come true. The sun sparkles off the cascading water as if someone were emptying a handful of

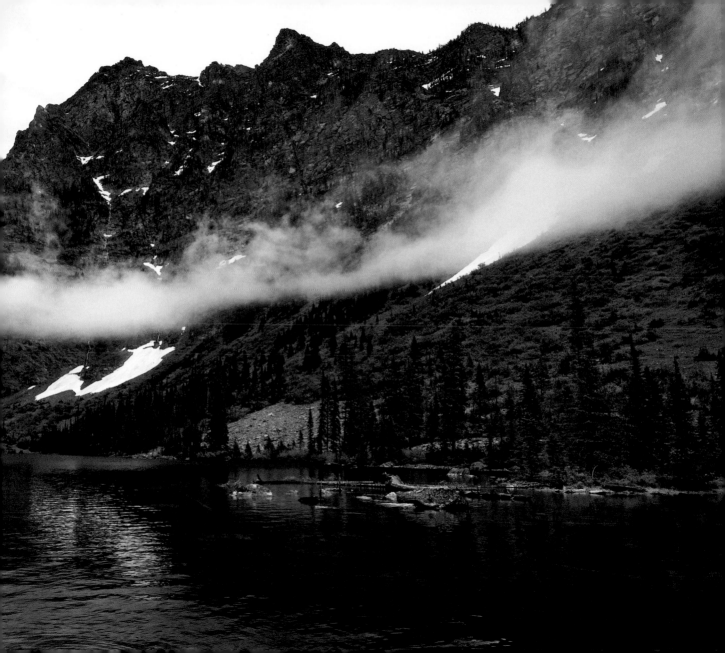

## Sperry Glacier

This glacier is situated on the north slopes of Gunsight Mountain immediately west of the Continental Divide. Although many geologic features of Glacier National Park were formed during the much longer period of glaciations ending over 10,000 years ago, Sperry Glacier, like all the glaciers in the park today, is a product of the recent Little Ice Age, the period of cooler average temperatures starting in about the 13th century and concluding in the mid-19th century. One of the largest glaciers in the park, the surface area of Sperry Glacier has retreated 75 percent since the mid 1800s. The glacier is named for Lyman B. Sperry, a professor from the University of Minnesota, who in 1895 was a party in an exploration of the region where the glacier is located.

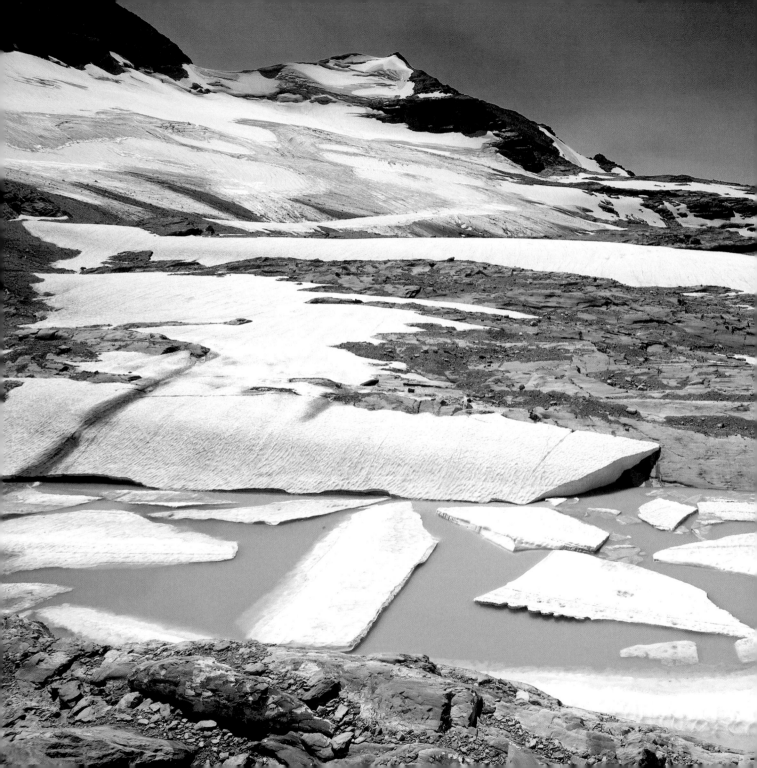

**American Red Squirrel**
Known as the "watchdog" of the forest, this little chirper
allerts when intruders invade it's teritorry.

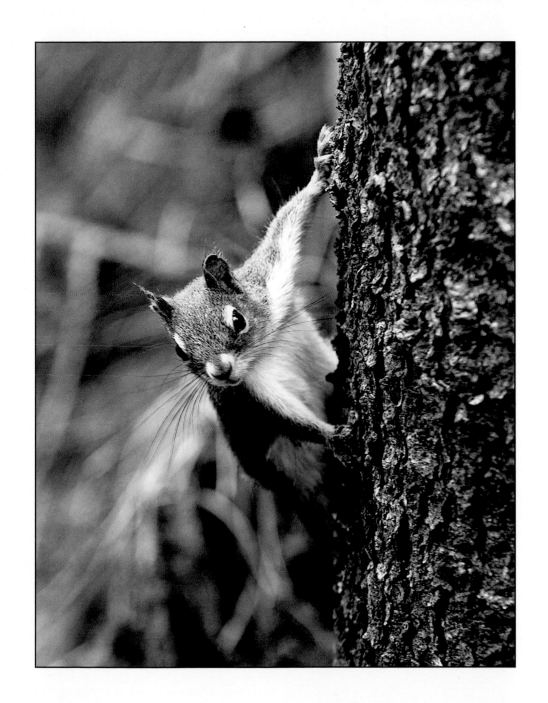

Spring in Glacier Park brings melting snows and rain. The combination makes the streams swell to capacity. Visitors to the park drive along a constantly changing series of waterfalls and cascades along the Going-To-The-Sun Road.

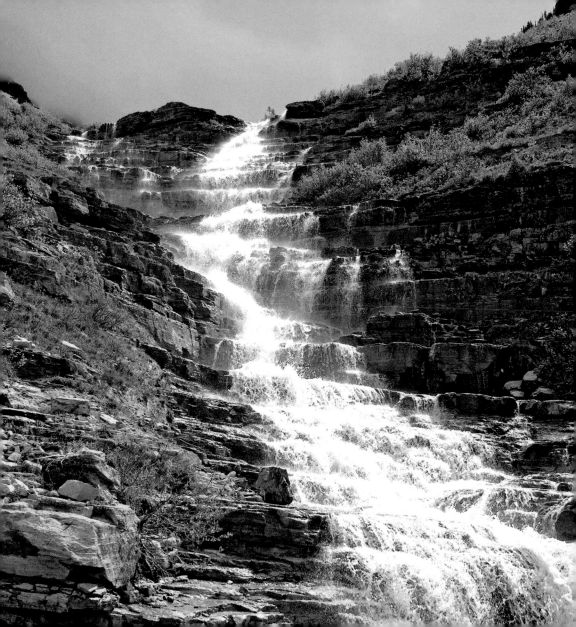

**Sacred Dancing Cascade**
The white water section of McDonald Creek starts at Sacred Dancing Cascade, then passes through McDonald Falls before feeding into Lake McDonald.

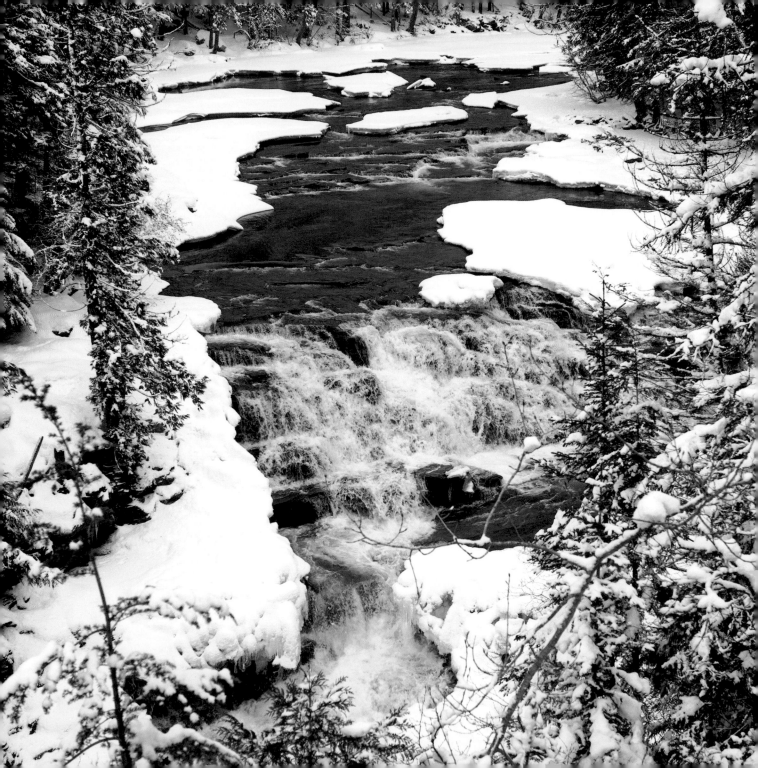

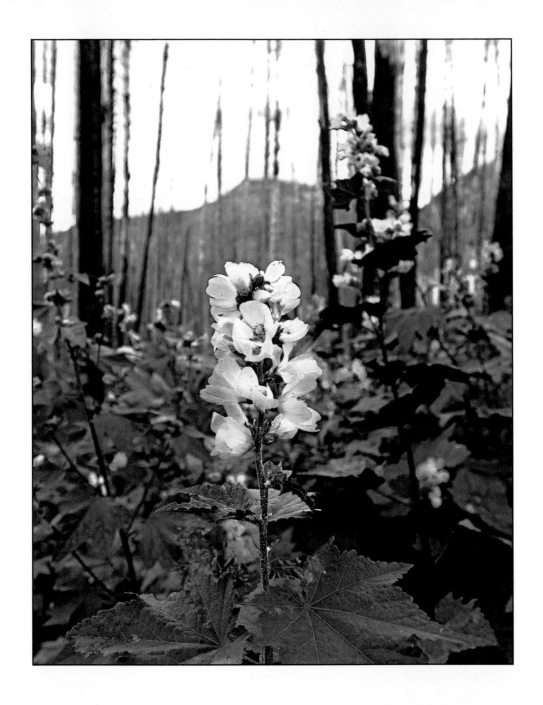

**Mountain Hollyhock**
seed exists in the soil for many years but germinates and
blooms after a major fire prepares the environment.

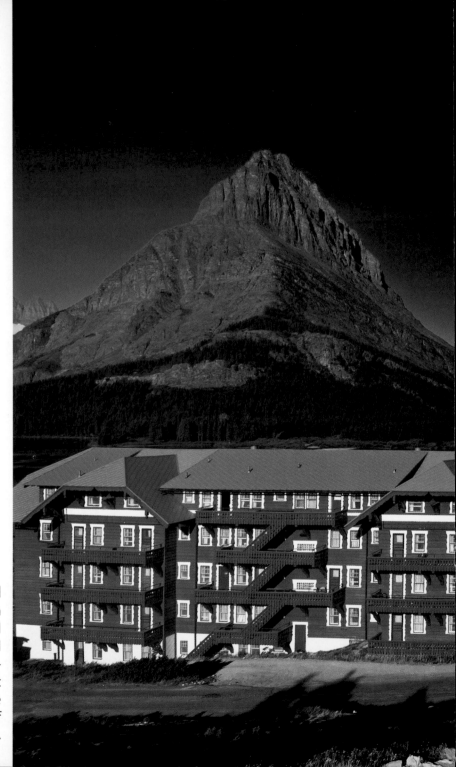

### Many Glacier Hotel
Built by Louis Hill and the Great Northern Railway in 1914-1915, Many Glacier Hotel is the largest hotel in the park. The hotel was modeled after chalets found in Switzerland. A Swiss theme is apparent throughout the hotel, especially in the main dining room where the flags of Switzerland's cantons adorn the walls.

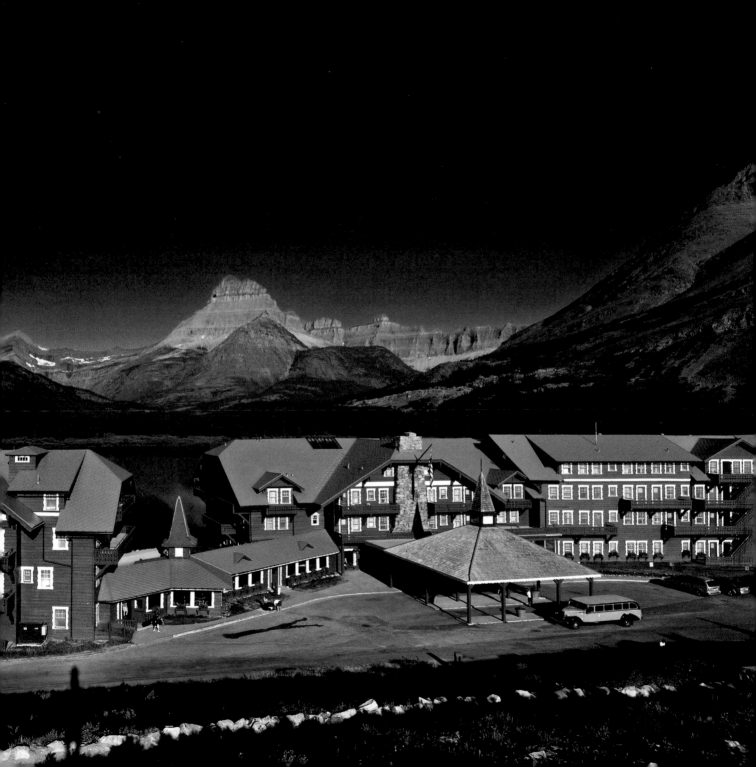

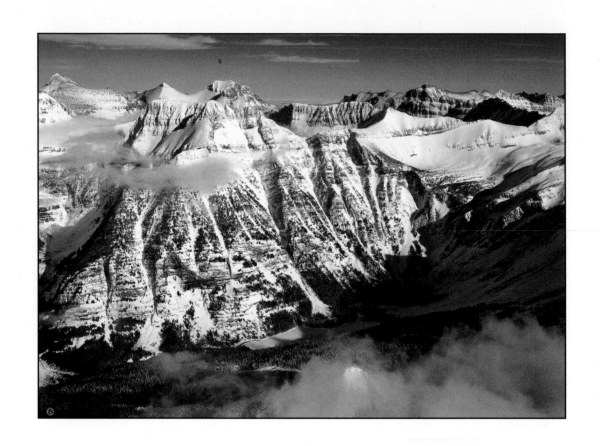

### Avalanche Lake

This beautiful lake sits just below the Continental Divide on the west side of Glacier National Park. An excellent and popular trail follows roaring Avalanche Creek through dense wood up to the lake.

The lake is ringed by very dense and lush vegetation. The Continental Divide acts as a storm stopper, and the closer you get to the barrier, the more precipitation. Thus, the area features trees and vegetation much more akin to the lush coastal forests of the Pacific Northwest.

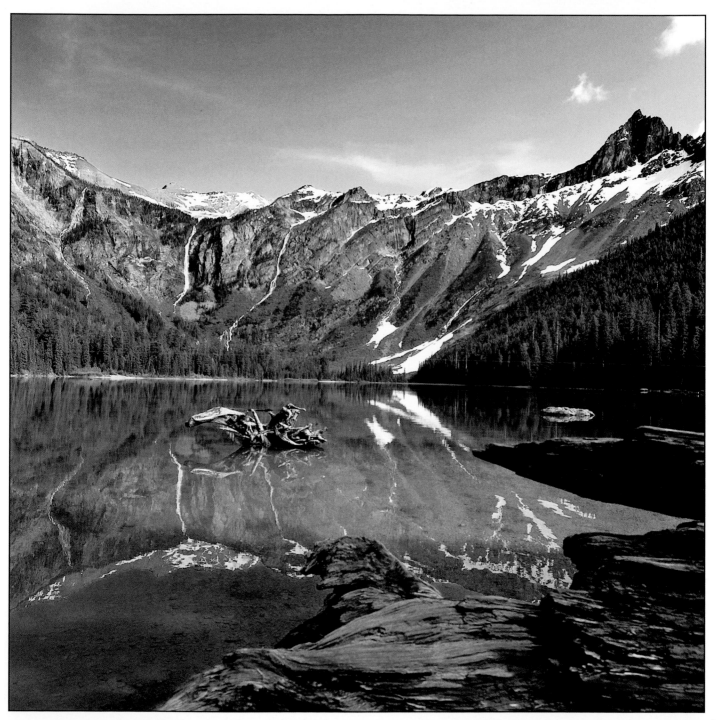

51

## Maria's Pass

The Lewis Thrust Fault is seen from near Maria's Pass. The fault shows up as a thin line of light tan rock about halfway up Little Dog and Summit mountains.Below the line is Cretaceous-age rock about 70 million years old, above it Altyn limestone was formed some 1.6 billion years ago.

Former  Great Northern Railway crossed the Continental Divide at Marias Pass, on the southern border of the Park. Little Dog Mountain (8,610 feet) and Summit Mountain (8,770 feet) in Glacier National Park form a majestic background.

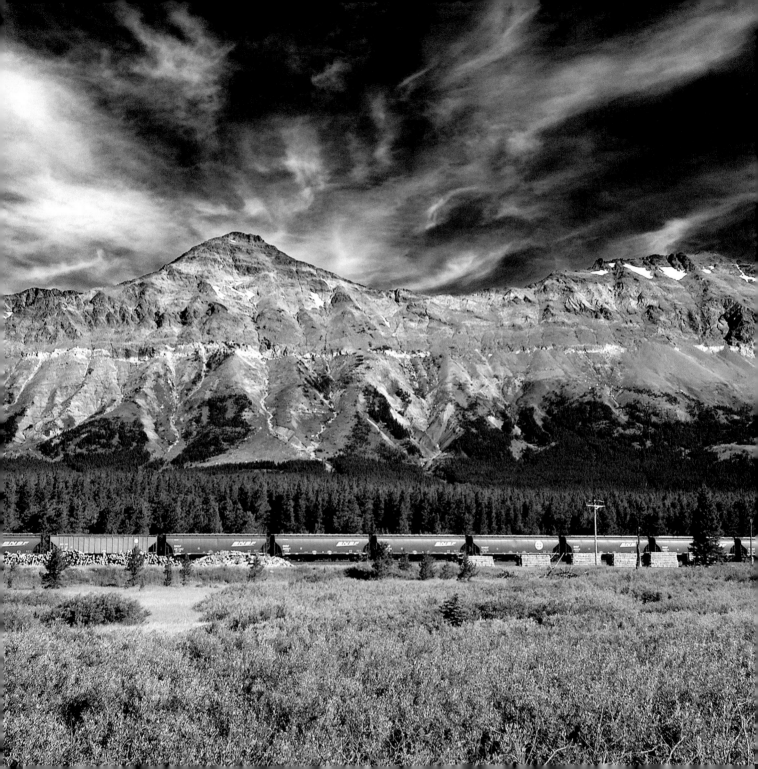

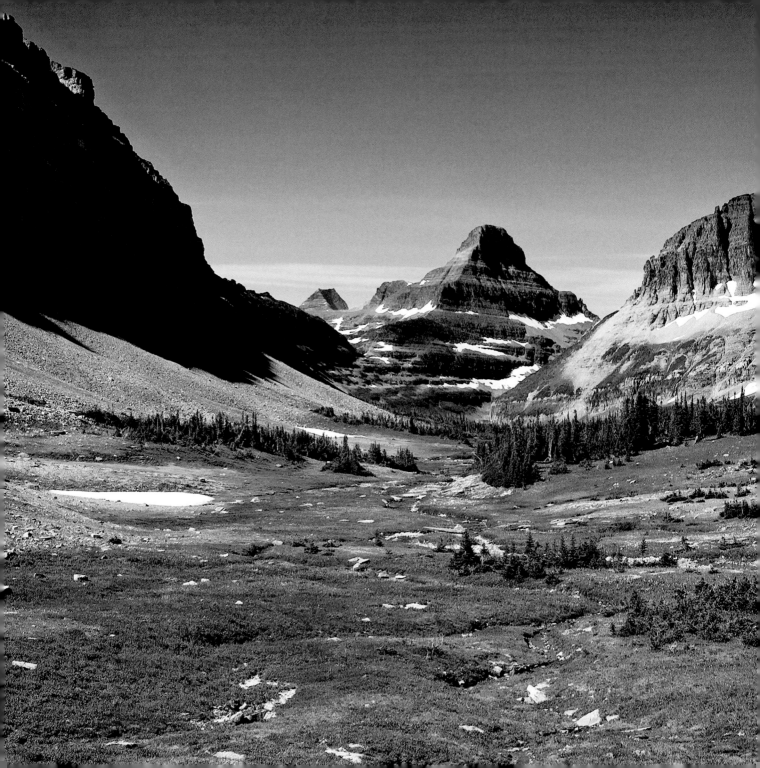

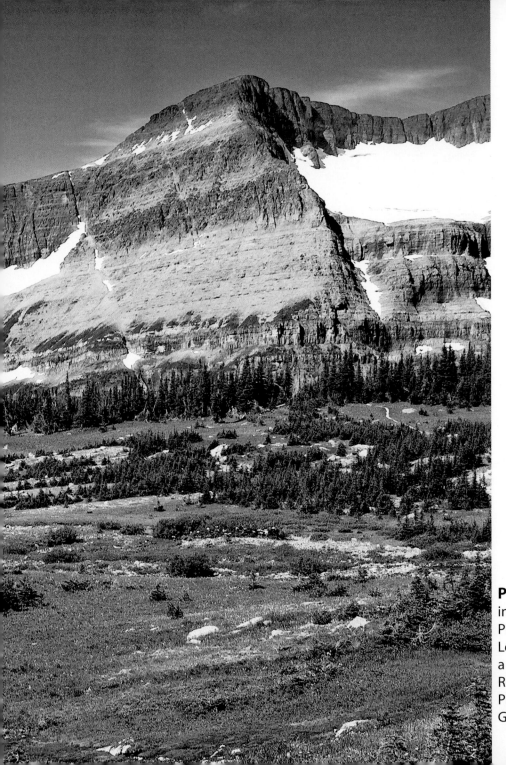

**Preston Park**
includes the junction of Siyeh and Piegan pass trails.

Looking back towards Logan Pass is a superb view dominated by Mt. Reynolds (9,125). The upper ridge of Piegan Mountain shelters Piegan Glacier (on the right).

55

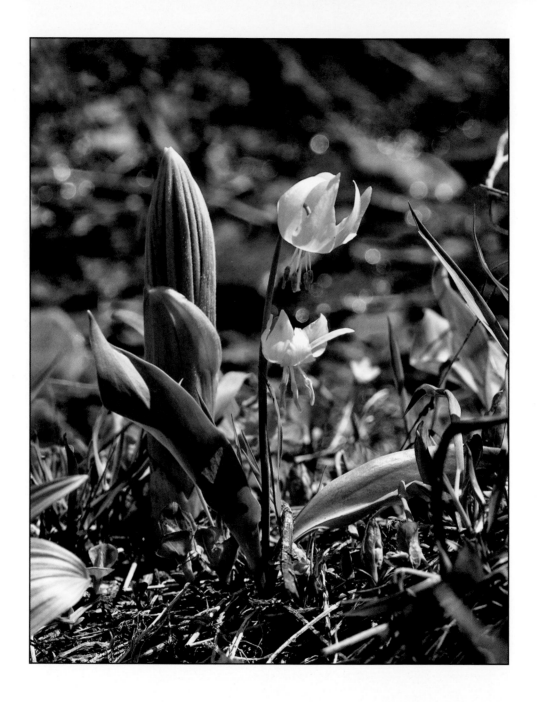

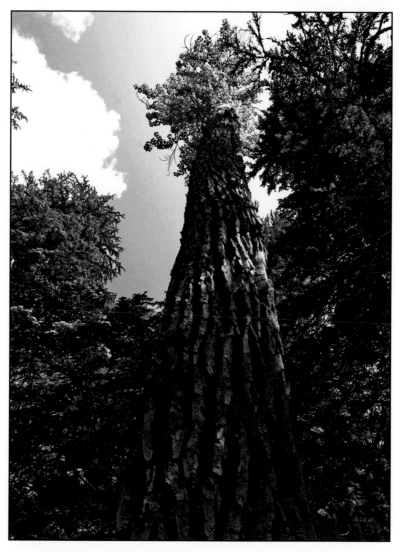

Ancient Cottonwood developed deep bark ferrules.

## Glacier Lilies
One of the first wildflowers to emerge as the accumulated winter's snow begins to recede, the Glacier Lily can be found in abundance.  From early spring in the open valley forests at the lowest elevations to late summer in the high alpine meadows, this spectacular wildflower delights all who visit.

**Blackfoot Mountain (9,574)**
This mountain and glacier was discovered and named for the Blackfeet Indians by George Bird Grinnell on a trip to the head of the St. Mary Valley in 1891. Blackfoot Glacier was called "Old man Ice", by the Kootenai Indians, Red Eagle glacier was "Old Woman Ice", Sperry Glacier was "Son Ice", and Pumpelly Glacier was "Daughter Ice".

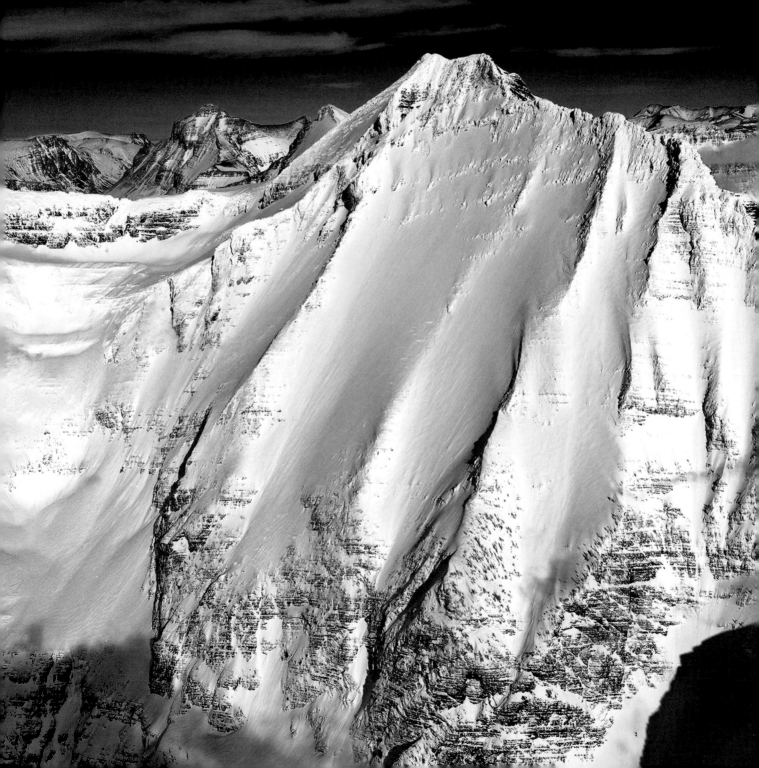

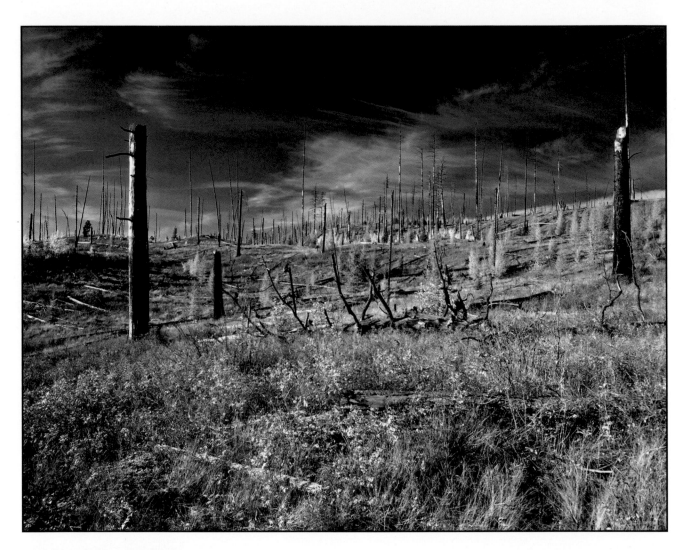

### Red Bench Fire Exhibit

Touched off by a smoldering snag across the valley, the 1988 fire jumped the North Fork and burned irregularly through an area of 38,000 acres. One firefighter was killed, 19 injured, and several structures were destroyed near Polebridge.

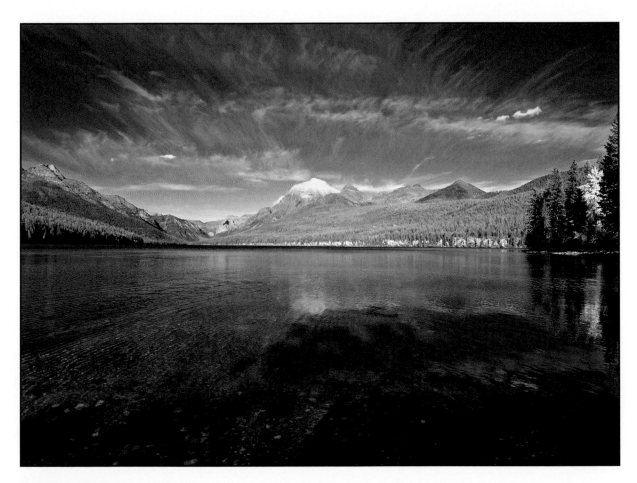

### Bowman Lake

Sits in a narrow trough northeast of Polebridge. Its six-mile span sprawls uplake toward nesting bald eagles and Thunderbird Peak (8,790); its half-mile width squeezes in between the hulks of Numa Peak (8,520) and Rainbow Peak (9,891), which rises 4,500 feet straight up from the south lakeshore.

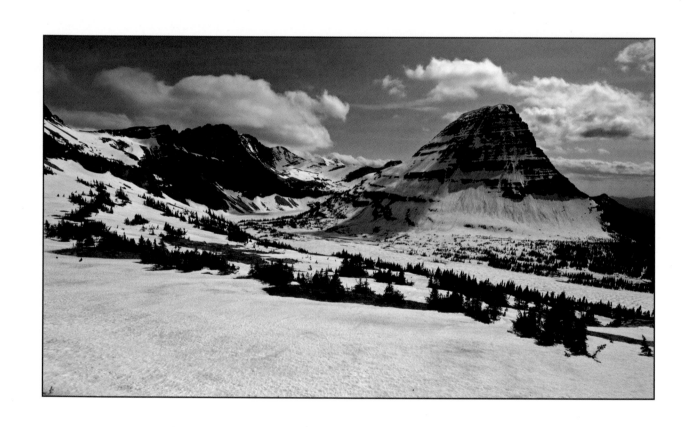

### Hidden Lake

An easy 1.5 miles hike from the Logan Pass Visitor Center opens the panoramic view from the Hidden Lake overlook on the frozen Hidden Lake and the extensive snowfields on the circling cliffs.

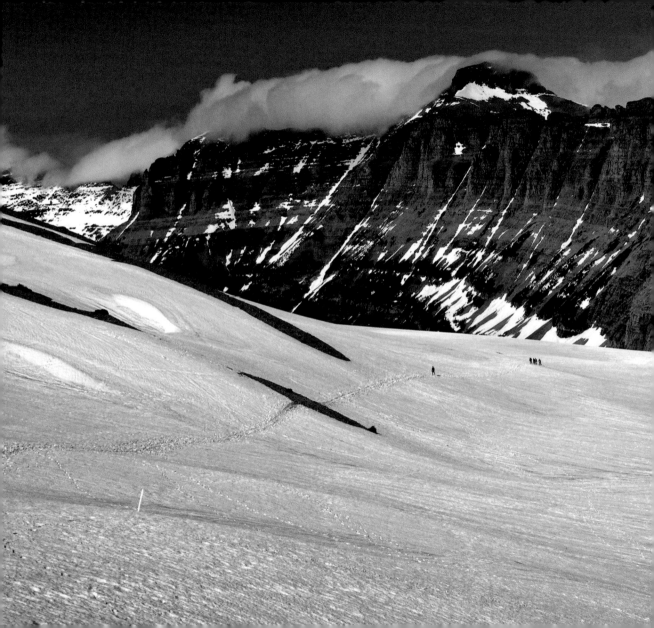

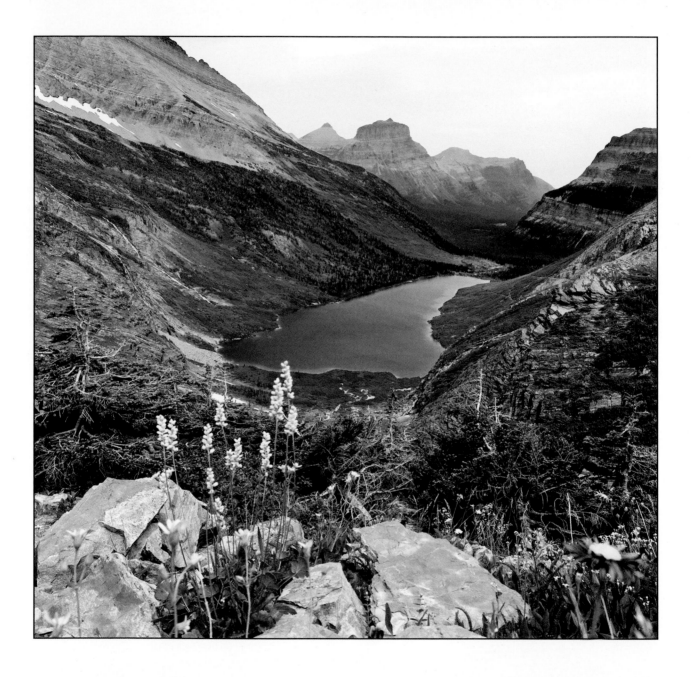

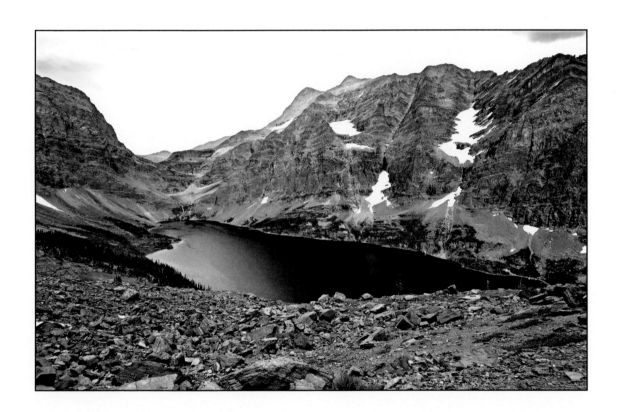

**Gunsight Pass**
divides the drainage betweenGunsight Lake (on the left) with the full length of St. Mary Valley and the Lake Ellen Wilson (on the right), named in honor of President Wilson's first wife.

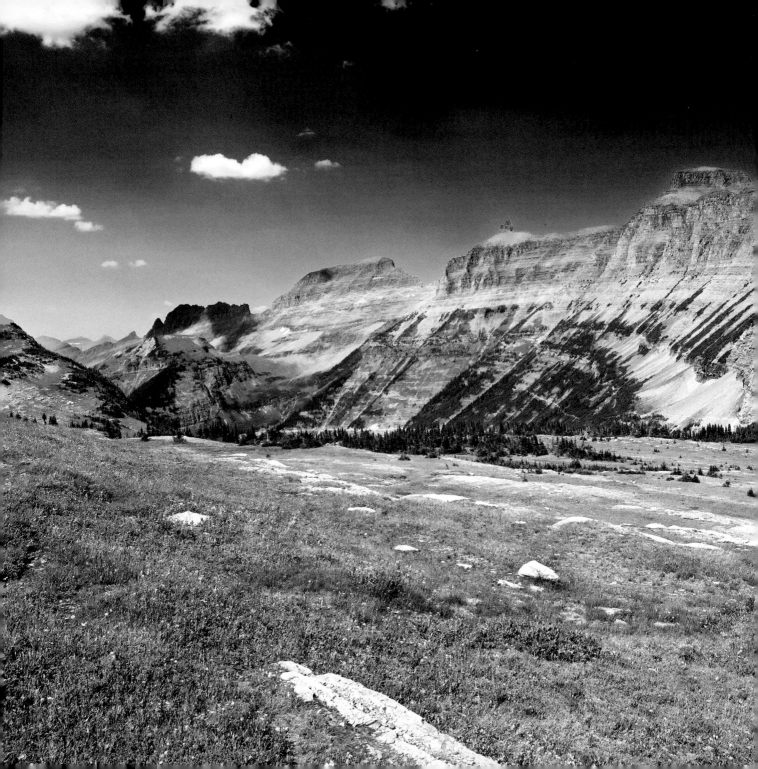

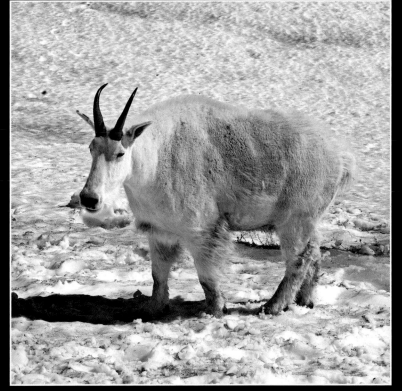

The mountain goat has been the symbol of the Great Northern Railroad and Glacier National Park for the last 100 years.

## The Garden Wall

This long, knife-edged ridge, forming that section of the Continental Divide between Logan and Swiftcurrent Passes, was so named by one of George Bird Grinnell's parties which were camped at Grinnell Lake in the late 1890's. One evening, around a campfire, they were singing the currently popular song, "Over the Garden Wall", when one of the party remarked, "There is one wall we cannot get over", and the name was immediately applied to the ridge.

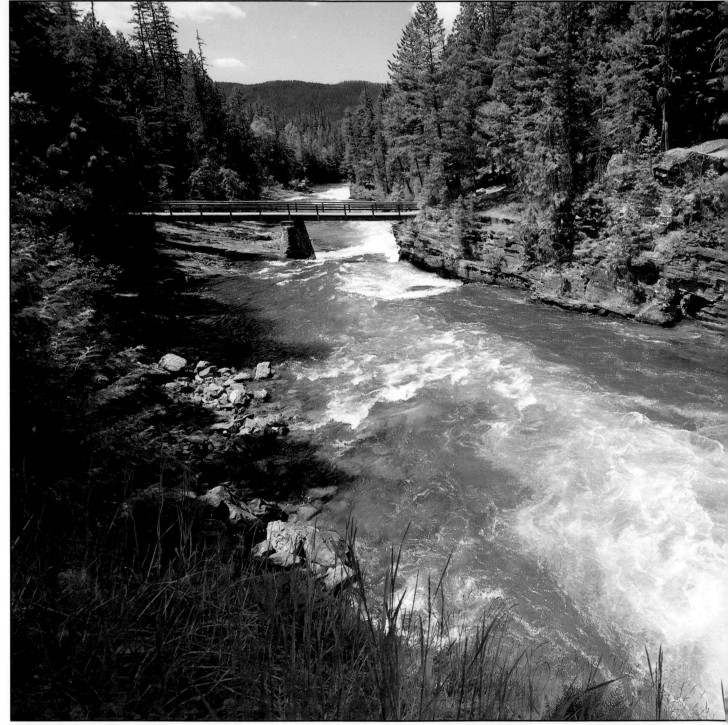

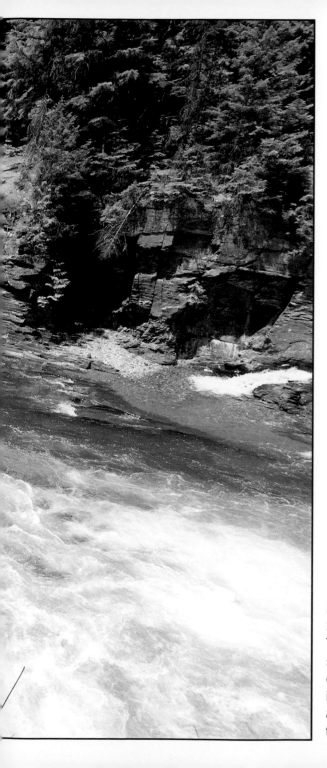

## McDonald Creek

Spring in Glacier brings melting snows and rain. The combination makes the rivers and streams swell to capacity. Visitors to the park drive along a constantly changing McDonald Creek. One minute it presents a calm multicolored ribbon of water and the next, a torrent of white foam that forcefully illustrates the power of moving water.

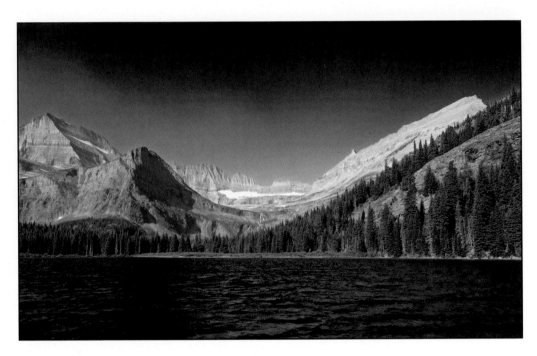

Josephine Lake lies bellow Mt. Gould and the garden Wall. Can you see the salamander in the Salamander Glacier?

### Singleshot Mountain

is the first peak that one passes when driving into the park on the Going-to-the-Sun Road from the East Entrance. The 7,926 feet peak was named by James W. Schultz when G. B. Grinnell shot a bighorn ram here with a single shot.

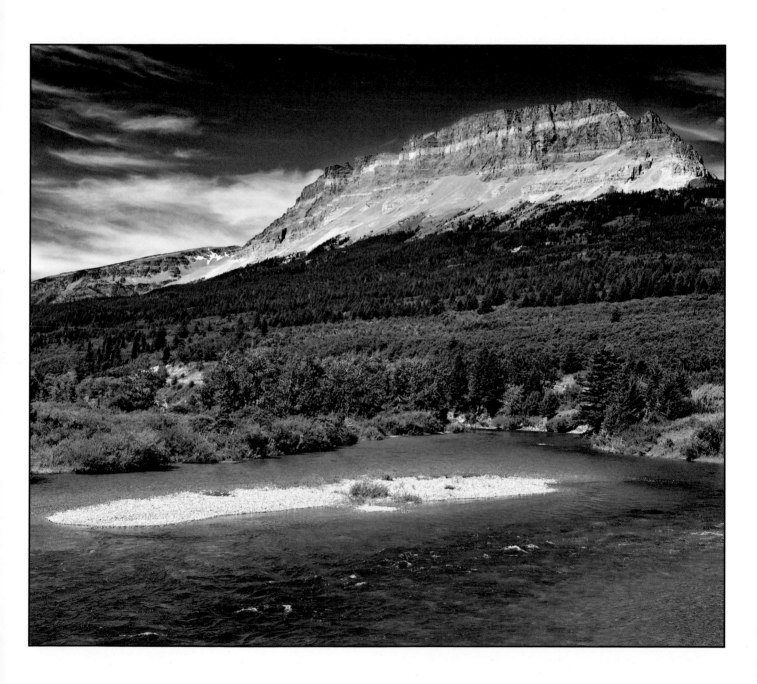

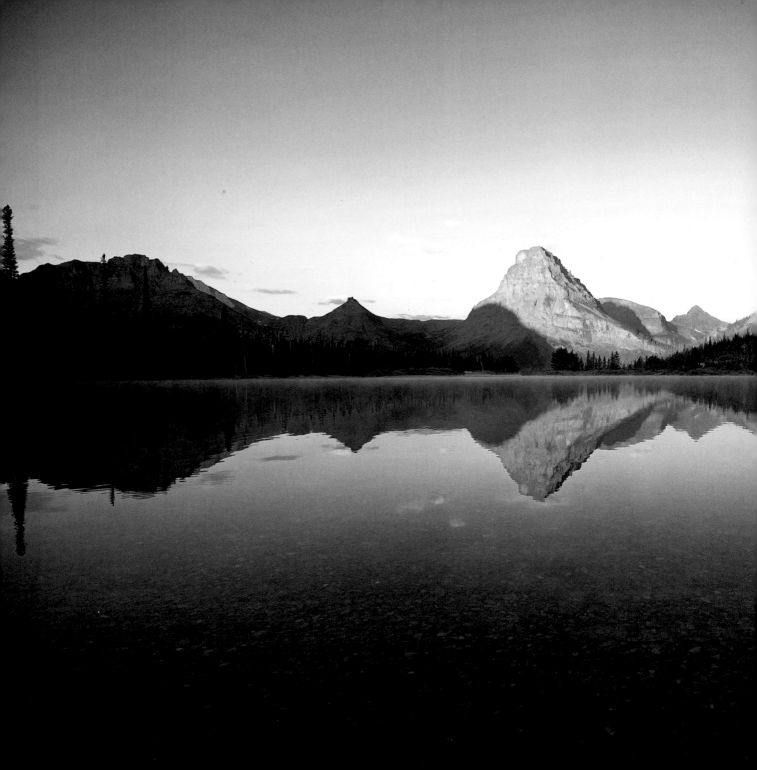

**Two Medicine Lake**
A quiet glacial lake, over two miles long and 260 feet deep reaches an altitude of 5,164 feet. In the center shadow is Painted Tepee Peak (7,650) and to the right Sinopah Mtn (8,271).

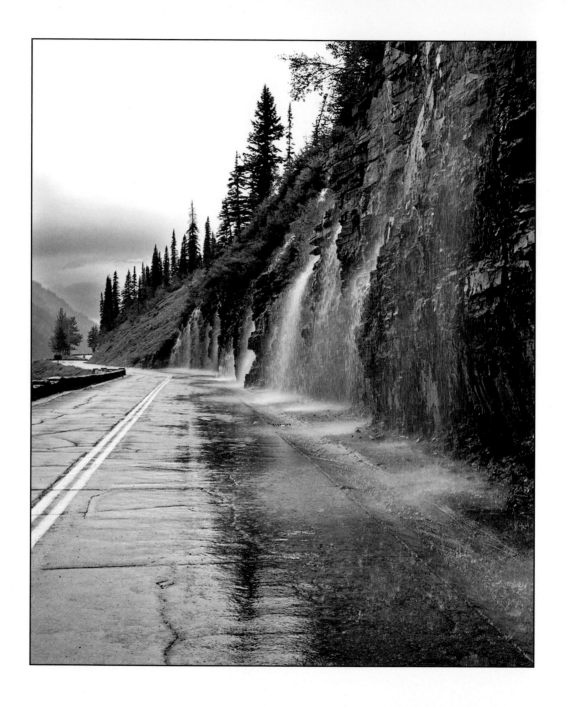

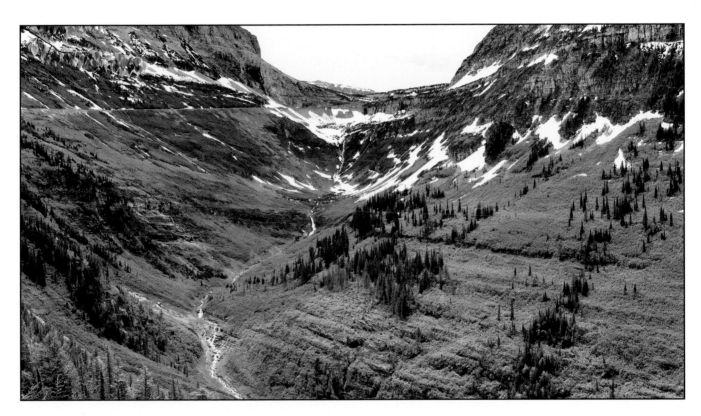

Looking up the Logan Creek Valley to Logan Pass.

**Weeping Wall**
During the early park season, water laces this cliff at the base of Haystack Butte, which is known as the Weeping Wall.

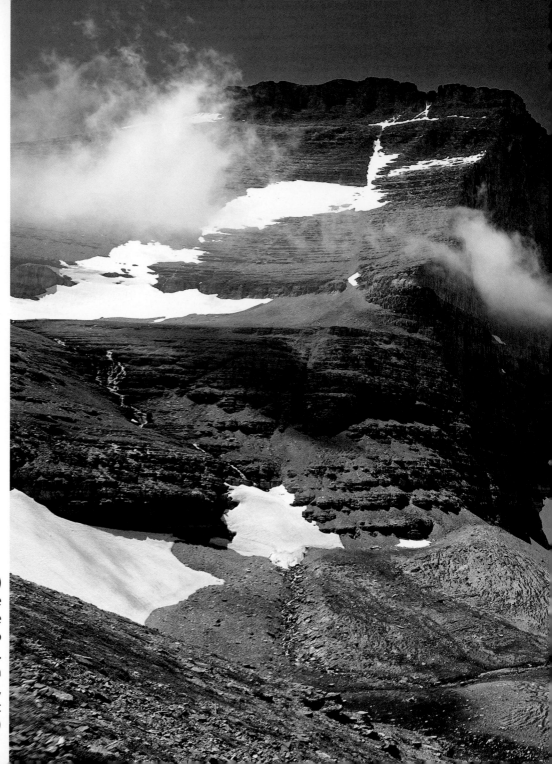

**Piegan Pass (7,570)**
This view reveals a remarkable character of the east side Garden Wall culminating to Mt. Gould (9,553). Piegan Pass trail passes within three life zones (Canadian, Hudsonian and Alpine-Arctic zone)

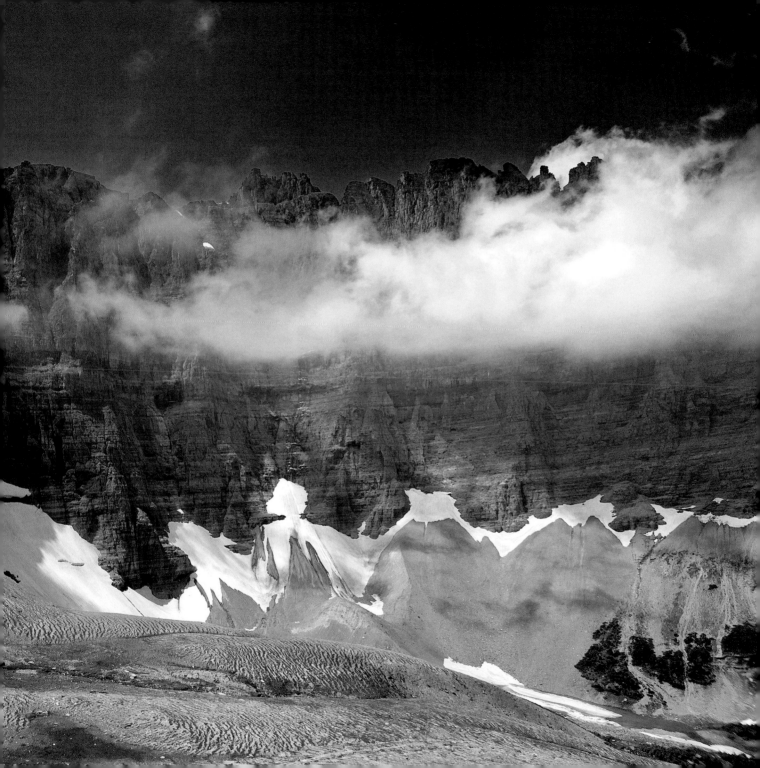

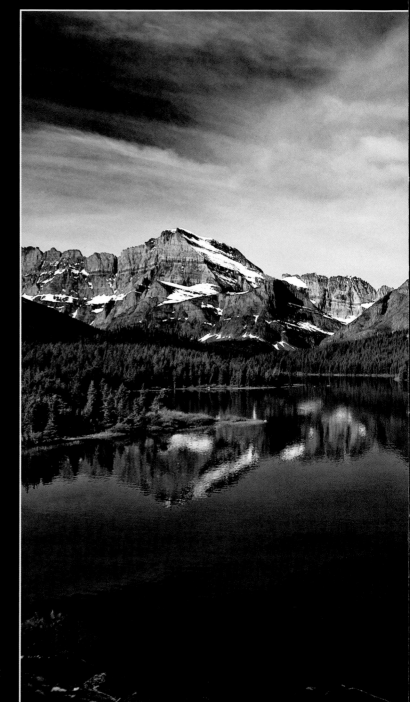

### Swiftcurrent Lake

Swiftcurrent Lake lies more than 3,000 feet
below Mount Gould, Grinnell Point, and
Mount Wilbur

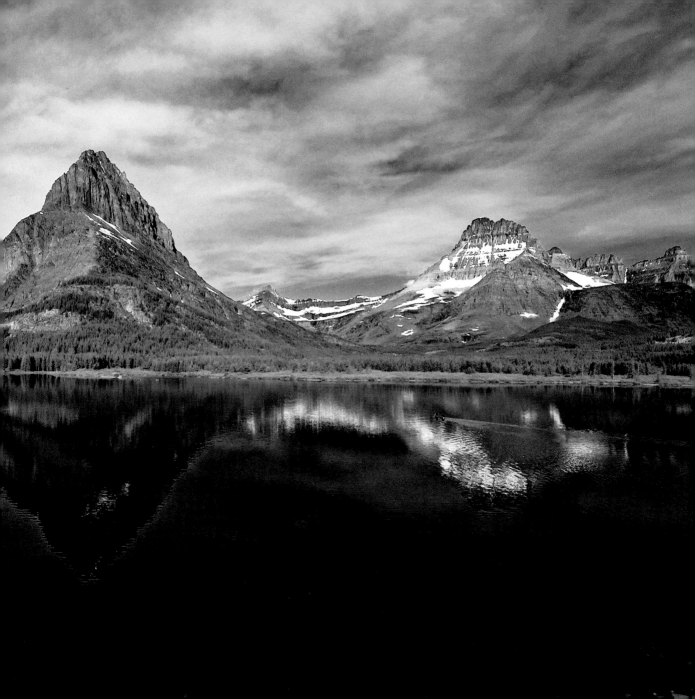

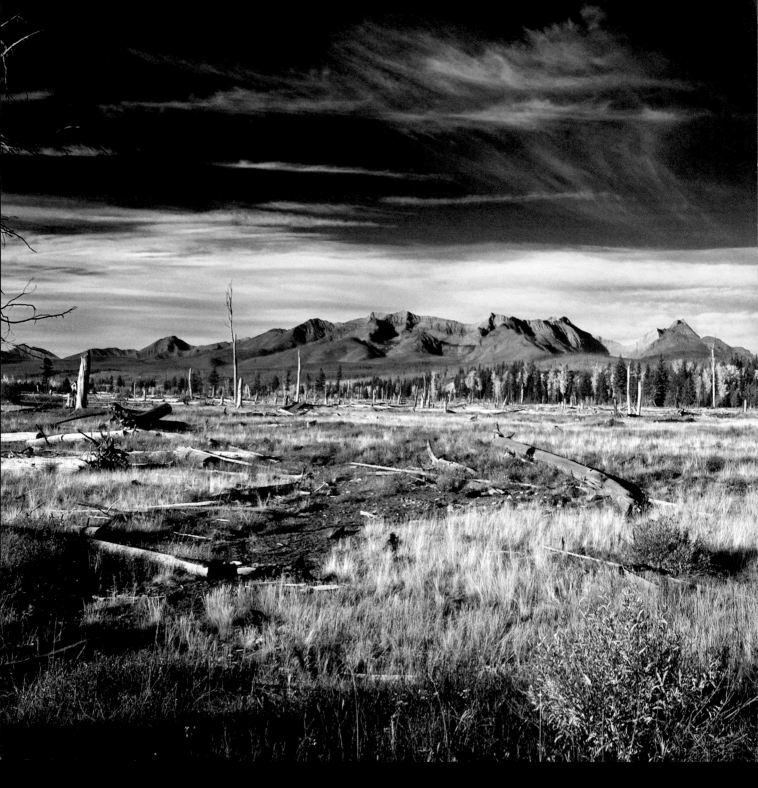

## Polebridge / North Fork Road
Named for the log bridge that connects the North Fork Road in Glacier National Park to the rustic community of Polebridge, 35 miles northwest of Columbia Falls.

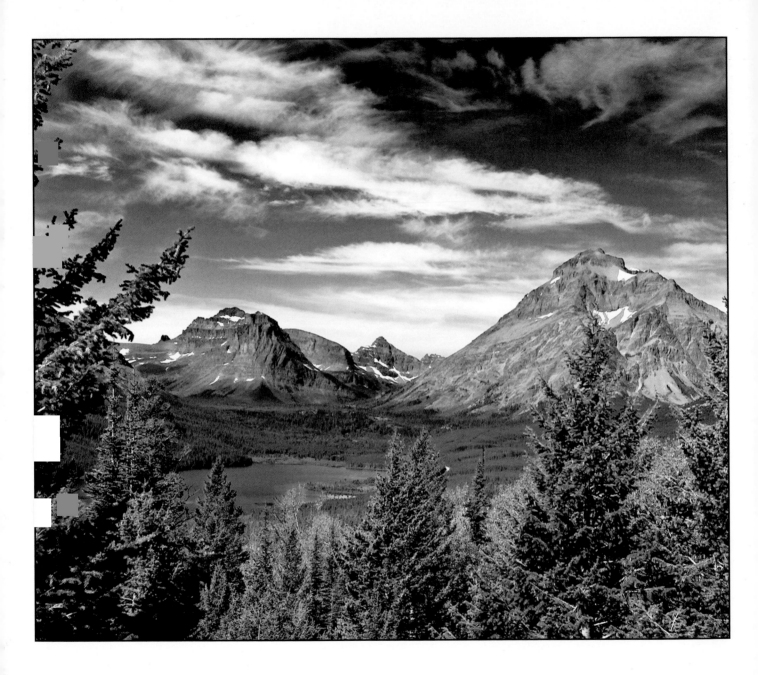

Two Medicine Country in southern
Glacier National Park.